His Life
Through My Eyes

Gobi M. Rahimi

PROMONTORY
PRESS

Promontory Press
www.promontorypress.com

ISBN: 978-1-927559-98-7

Additional photography by Frederique Barrera
Cover design by Marla Thompson of Edge of Water Designs
Interior layout and typeset by One Owl Creative

Printed in The United States of America

Dedicated to my son Arya Michael Rahimi. You are a true warrior and have fought more battles in 3 years, than most in a life time.

Acknowledgements

I place at the top of my list of acknowledgments the creator. I thank you for the blessing of life. Tupac Amaru Shakur, thank you for always speaking your truth as you did, in your work as well as your life. You lived and died a warrior. Your legacy is a blessing for all future generations. Afeni, thank you for your strength, courage, and wisdom. Thank you for bringing Tupac into this world. Tracy, I would have never met Tupac if it weren't for you. Thank you for the experiences and the lessons. To my friends and family, thank you all for putting up with me, and thank you for your loving support.

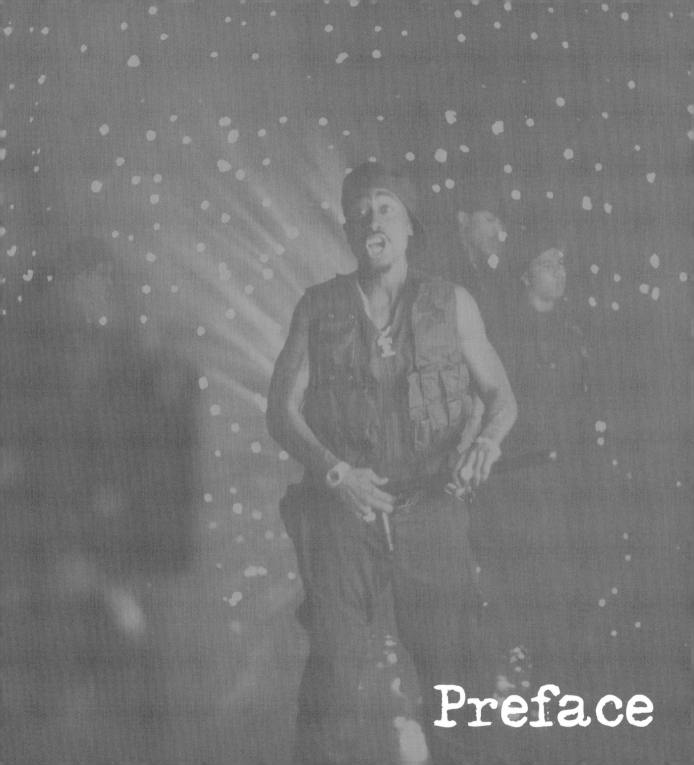

Preface

The photos of Tupac in this collection chronicle the last days of his life. They document from the end of 1995, up to his death in 1996.

I became a trusted business partner and friend of Tupac Amaru Shakur during the last eight months of his life. Tracy D. Robinson and I had started a film company with him called 24-7 Productions. I suggested this name because working with Tupac was a 24-7 proposition. Tupac's intention was to create a minority owned Production Company, and shape it into a force to be reckoned with in the film industry. 24-7 had a potential three-picture deal a week prior Tupac's death. I had the pleasure of producing and directing many of Tupac's music videos. I witnessed a young successful African-American man live and die before he had a chance to realize his full potential.

Tupac Amaru Shakur was born on June 16, 1971 in New York. His mother, Afeni Shakur, was arrested along with other members of the Black Panther organization on 189 felony charges that included thirty counts of conspiracy. Though she was eventually acquitted of the charges, Afeni spent eleven months in jail before being released. Once on bail, she became pregnant with her son. I remember hearing stories of how Afeni would fight to get one egg and some milk, in order to nourish her son. She once was quoted as saying, "This is my black prince. He's going to save the black nation." Afeni was acquitted thirty-one days before her black prince was born. She named her son Tupac Amaru after an Inca King. The name itself means "shining serpent". Tupac received his last name from Mr. Lumumba Shakur, the son of Aba Shakur, a strong and very well respected family in the Black Nationalist movement. Shakur means "thankful to God" in Arabic. One of the most influential male role models in Tupac's adolescent years was Dr. Mutulu Shakur. Dr. Shakur influence helped shape

Tupac into a man determined to address social and political issues. Dr. Shakur is still incarcerated as a result of helping Asada Shakur escape the country and alleged armored truck robberies.

The majority of Tupac's songs make social and political commentary; to simply call him a rapper, especially compared to what rap music is today would be a huge travesty. Tupac's roots and upbringing came from the black struggle. He was a by-product of hundreds of years of oppression, and came from a generation of warriors fighting for their right to equality. Tupac was like a dormant volcano; beneath the surface lay many layers. He had a will to live, to love and to create magic, but was fueled by all the frustrations, anger and injustice that shaped him. He was a trendsetter and a threat.

In the early 1990s, I married an Iranian - American filmmaker. Together we produced a spec music video and in that process I found a passion for filmmaking. A month later I decided to quit my job as a real estate agent in Orange County to become a music video producer. The marriage didn't last, but my newfound passion did. A year later I met Tracy D. Robinson. Tracy had a

small production company and together we started producing Hip Hop music videos. Prior to our meeting, she had worked on a Tupac Shakur music video as a production assistant and was so enamored with him, that she pledged her undying loyalty. Approximately a year after Tracy met Tupac, he was thrown into Danemora State Prison in upstate New York on trumped up rape charges.

Suge Knight, the CEO of Death Row Records paid over a million dollars (an advance against royalties) in bail money for Tupac's release in exchange for a three album record deal from Tupac for his label. Immediately after his release from prison, Tupac went straight into the studio to record *All Eyez On Me* and was put on a rigorous music video production schedule. Upon completion of his first video, *California Love* with Dr. Dre, Tupac sent his (at that time) assistant Molly Monjauze to find Tracy. He wanted Tracy to produce his next music video. By default, I was a part of that package. I didn't know much about Tupac prior to meeting him, but like Tracy, I too was immediately mystified by his persona and character.

Growing up in Iran, I often heard of the

Dervish, a person who possesses a dynamic and heightened sense of awareness. Much like the shaman or the prophet, these beings are not always accepted by their society or tribe, but often act as a powerful force in shaping it. Tupac possessed many of these qualities. His artistic contributions to music, film, and poetry are unparalleled. Tupac was an important person, not only to African-American culture, but also to world culture. His music and acting set precedents that have been duplicated by many who have followed in his footsteps. From the moment I met him to the day he died, I considered myself as one of his soldiers and always will. Tupac was an artist, a warrior, and a poet. During his short life, he achieved those titles with his talent, his persistence, and his tenacity.

Tupac loved to listen to Don McLean, Marvin Gaye, Hall & Oats, Stevie Wonder, David Bowie, Elton John, and Alanis Morissette. He read Shakespeare, Sun Tzu, Maya Angelou, Khalil Gibran, and Thomas Moore to name a few. He was also well versed in world religion.

After Tupac's passing, I remember reading much of his fan mail. Letters poured in from Bulgaria, Russia, Poland, South Africa, and my homeland, Iran. I was amazed by his international influence. As Mr. Quincy Jones so aptly stated in his book, if he had died at the age of twenty-five, his legacy would have been remembered as a big band musician. If Malcolm X had died at the age of twenty-five, he would have been known only as a street hustler named Detroit Red. Tupac by the age of twenty-five had starred in five feature films and had sold millions of albums.

I was privy to a transforming Tupac. A Tupac on his way to autonomy and maturity. I often feel that if he had lived just a bit longer, he would have been able to complete his obligations and move on with his own plans. He had started a film production company and a record label of his own. He lived the life of a mythological character, like a Luke Skywalker with a fair share of Darth Vaders around him. His aspirations were never ending, his spirit eternal. Meeting him has been one of my life's great pleasures, his death one of my life's greatest disappointments. I will miss him dearly and I will mourn his death for the rest of my days. He changed me, and because of him I am a better person. May peace be upon him.

I feel in judging Tupac, most people take for

granted that he was only twenty-five years old when he died and that he grew up under the intense scrutiny of the public eye. During his short life and since his death, the media has focused solely on aspects of his being that feed into black stereotypes. Some of what has been neglected about his character is that Tupac was a very sensitive young man, and was deeply affected by the suffering of oppressed people. He also had a lot of plans for the future that involved politics, social change, and charity. As time goes on, my respect, admiration, and awe continue to grow rather than die away. It was a privilege to have spent the last months of his life with him. He was irresistible and impacted everyone who crossed his path.

His Life
Through My Eyes

The first time I actually met Tupac was on a sunny California day at a beach house that was rented for him, in Malibu. When I arrived, Tupac was having a business meeting, while The Outlawz ran around the backyard having an all-out war with water guns. It was the end of February, still cold, but sunny. I sat on a lawn chair, pulled up the collar of my leather jacket, and watched as the "thugs" ran around, wreaking havoc. At one point Pac grabbed a water gun and joined the water gun fight. As he did this I wanted to join in. I wanted a chance to break the ice, and it simply looked like fun. Just as I thought about joining in, Tupac put his gun down on the table next to me and got on the phone with Suge Knight. I waited about ten minutes to see if Pac would come back, but since he didn't I picked up the gun and examined it, wanting to be noticed by the others. They took the bait. Before I knew it, Mutah of The Outlawz started squirting me with water. I jumped up and squirted him back. Within a matter of seconds all the Outlawz surrounded me and started to spray me from every direction. I would not surrender, and continued my feeble attempt at soaking them. Tupac ran into the middle, pushing them aside. "Now that's what I'm talking about," said Pac, "you motherfuckers surrounded him, outnumbered him, but he still didn't give up. This is one crazy Iranian." From that day on, "crazy Iranian" became my nickname.

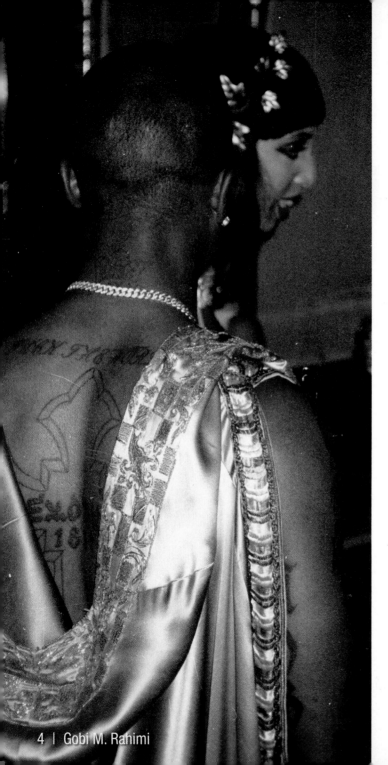

Tupac was an old soul. Meeting him for the first time felt familiar, as if I had known him in a previous incarnation. Class or status didn't matter to him. He was accepting and acknowledged everyone. I felt his prophetic energy and wanted to protect him however I could. In my head, I felt like I was an older brother that could help him fend off some of the drama that surrounded him.

In November 1994, I was in Los Angeles when a phone call from New York delivered the information to Tracy that Tupac had been shot outside a studio and was dead. Tracy burst into tears. This was the first time (and sadly not the last time) that I had seen violence bring sadness into Tracy's life. The next day, we found out that he was going to be okay and that he had already checked out of the hospital. He had been shot five times and insisted on leaving the hospital. I had later been told by one of his friends that he feared the shooters would try to finish the job. Years later I found out that when he had checked out of the hospital and, he had gone straight to the apartment of an actress friend of his at the time. He stayed at her apartment for a month, surrounded by his group the Outlawz (his circle of faithful soldiers) and his beloved family, undetected.

In 1995, Tracy and I had driven from New York City, upstate to the massive cement structure known as the CLINTON CORRECTIONAL FACILITY (Danemora), to visit Tupac in prison. I wanted to see him, but Tracy thought it best if I did not, as it had been some time since she herself had seen him and didn't know what to expect. I remember sitting in the car and thinking to myself, "Wow, Tupac Shakur is caged behind those walls."

Once I got to know Tupac, I reallized I realized that the "rape" charges against him were completely trumped up. Tupac never had to force himself on to anyone. It was simply the move of an opportunist, I often think Tupac would still be alive, had he not been incarcerated.

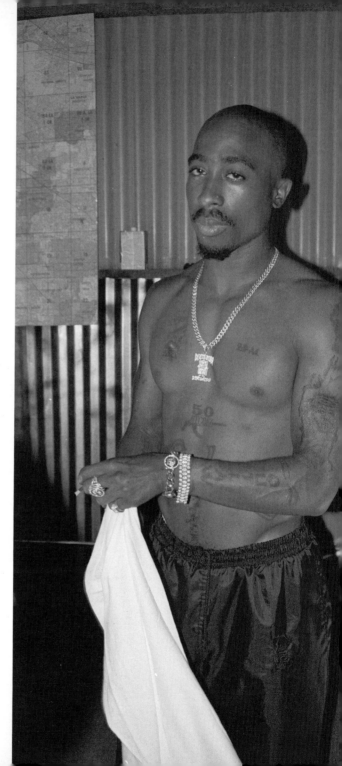

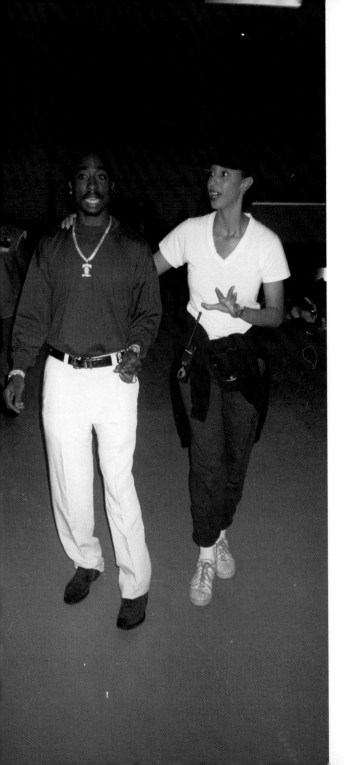

Tracy had been working in production when she met Tupac. They had an instant connection that eventually grew into a trusting friendship. Like so many others, Tracy was drawn to Tupac's shining energy and profound capacity to inspire others. Tracy says that when she looked at Tupac, it often seemed like he was glowing.

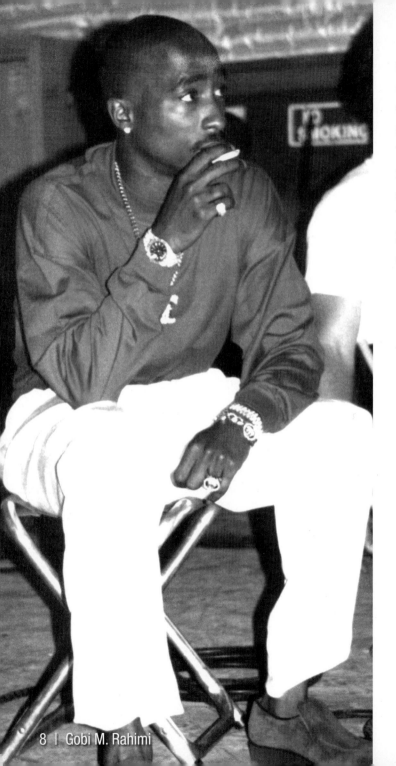

Other than the Outlawz and myself, his core support system consisted of women with strong personalities. His mother Afeni Shakur was the foundation of that system. Yaasmyn Fula (Yaki Kadafi of the Outlawz', mother) was Tupac's office manager and assistant in addition to Molly Monjauze. Yaasmyn brought Tupac trust and familiarity, while Molly was a loyal friend who he could rely on.

Tupac had an enormous respect and admiration for all women, especially black women. He took pride in helping women achieve their professional ambitions. His upbringing—growing up surrounded by a sister, aunts, female cousins, and his powerful mother, Afeni—kept him in tune with the struggles that women face.

He put Tracy in a powerful position and gave her a chance to shine in the male-dominated world of music video production. Above all, Tracy had Tupac's trust, something he did not give out freely to anyone. Shortly before his death, he had talked with both Tracy and I about his plans to bring his ideas to the big screen.

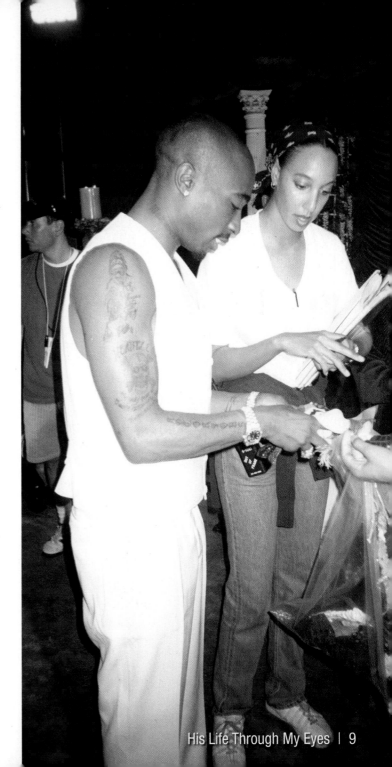

It was hard not to be charmed by Tupac. I wasn't simply a fan, but a loyal business associate and friend as well. I wasn't sure what his fate would be, but I knew beyond a doubt, that his life would definitely have an impact on urban and American pop culture. And I definitely had no idea that his impact would be global. As a director, I've been around a lot of celebrities, but I have yet to encounter anyone with his aura. There was something mystical and universal about him. He was more than just a black man or an American; he was prophetic.

A common sight; Tupac laying down the law with a blunt in his hand.

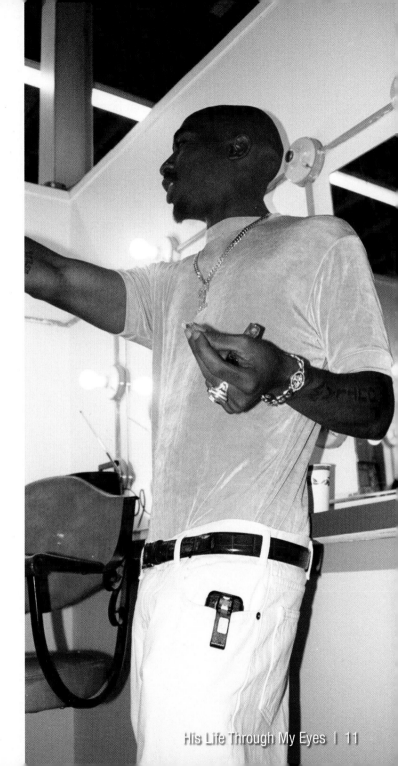

Tupac had more self-confidence than anyone I had ever met. I think it was the confident energy he projected that compelled everyone around him to want to please him.

When Tupac performed, he was like a shaman in a trance. He was dynamic. It was as if he were channeling some sort of universal energy. It was this ability of his that fueled his group, the Outlawz.

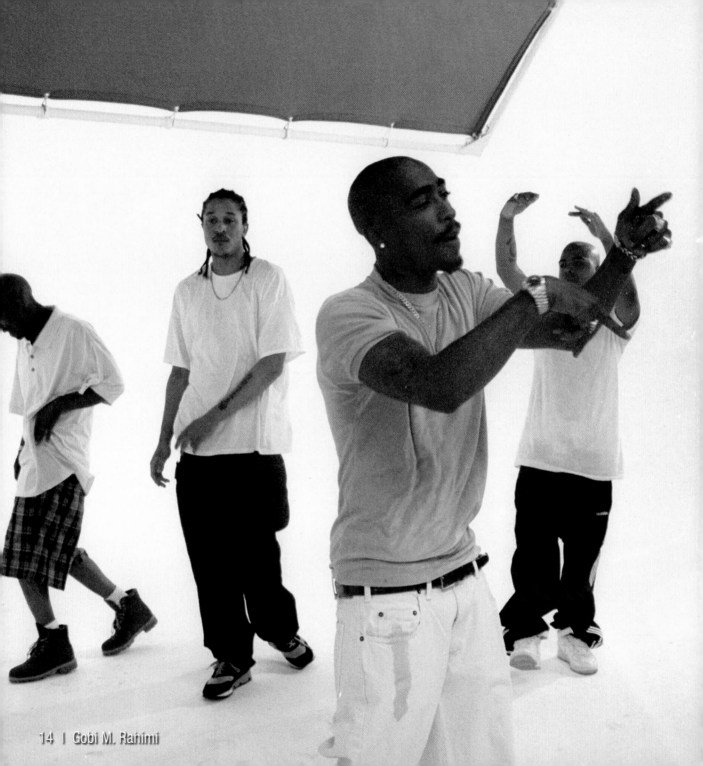

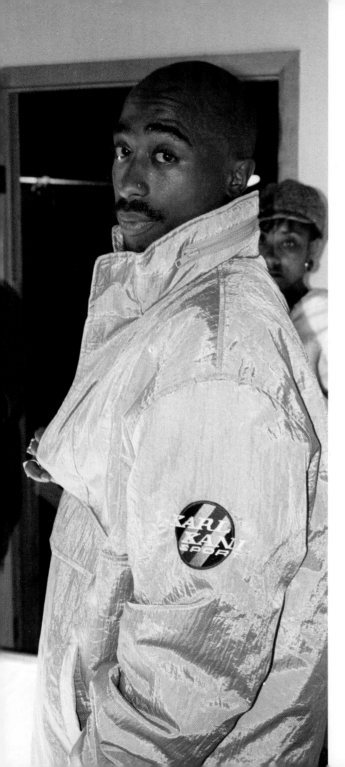

When Tupac signed to Death Row, he was on an intense production schedule. We shot a total of six big budget music videos within a few months, which was unheard of. I was amazed and intrigued by how much this man could accomplish in such a small amount of time. There was a sense of urgency in everything that he did. More than anything, I think he wanted to complete the terms of his record contract, so he could be autonomous. He was ready to take on both the film and music industries in a big way. In 1996, Tupac had created a film production company called 24-7 Productions with Tracy and I, and a record label called Euphanasia. Tupac named his record label Euphanasia by combining euphoria and euthanasia

Once the camera was rolling, he was "on" without any reservation or intrepidation. His performances always seemed so real because he was a master at creatively channeling all the positive and negative experiences of his life into what he was doing at the moment. The camera loved Pac.

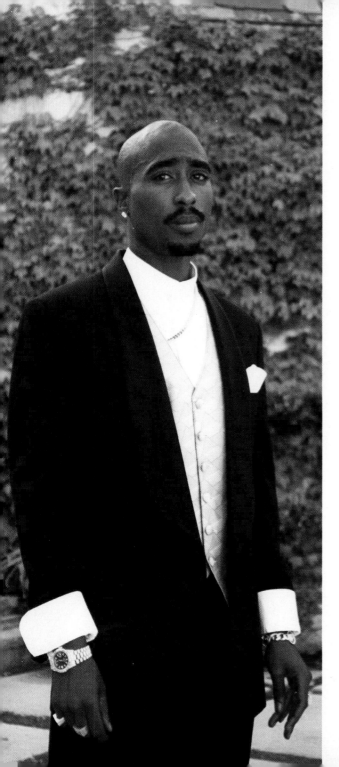

Pac's thug image faded away when he donned a suit. He looked like a prince or a dignitary. He was an innovator, and worked hard at portraying himself (Rapper/Actor) in an unexpected fashion.

Other than his family, there were only a few people that he trusted. Like a general, he had a small army of his own called the OUTLAWZ. The Outlawz were his group, loyal soldiers, and devoted disciples. Like himself, most of them were children of Black Panthers or the offspring of the black struggle. A keeper of the Shakur legacy, Tupac honored the soldiers whose lives touched his and whose sacrifice shaped his beliefs.

Pac was always coming up with unexpected creative ideas for us to execute. When we made the music video "All About You", Tracy along with a few of the other women on the production crew slipped on Egyptian garb to cut down on the overtime costs of professional models.

Tupac had a million-dollar smile. Women used to throw themselves at him. They would do anything just to get close to him. Men either envied him or resented him for how inadequate they felt around him.

When he performed on camera or in front of a crowd, you couldn't take your eyes off of him. He exploded into performance.

Tracy and I were producing a video titled "2 of Amerikaz Most Wanted" that featured Tupac and Snoop Dogg. The scheduled director, called two days prior to the shoot, announced that he did not want to direct the video because he didn't want to share credit with the artist, even if the video's concept was Tupac's idea. Tracy, knowing my desire to direct, suggested that I co-direct alongside Tupac. His response was "let the mothafucka do it."

"2 of Amerikaz Most Wanted" was my first directing experience and became one of the most heavily rotated videos in MTV history.

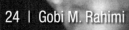

This picture is a good example of how Tupac's mood would change at the drop of a hat. This is Tupac in a typically pensive state in between takes.

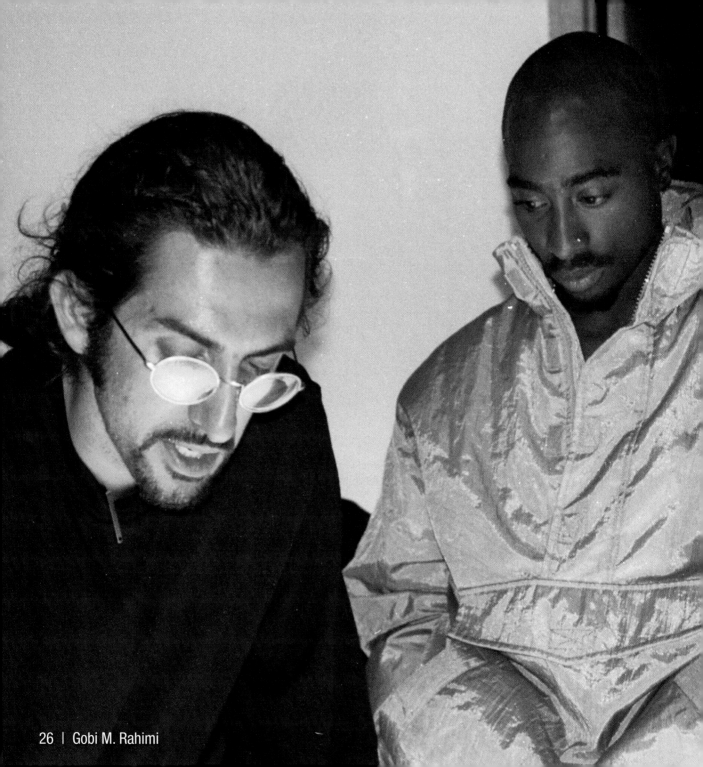

Here I am explaining how I intended to shoot the next set up.

Tupac was eager to get a couple of his own film productions going. To get the ball rolling, he came up with an idea for "Made Niggaz". It was to be a short film/music video that had all the elements of a narrative story line, with three music videos feathered throughout.

Tupac expected nothing but 100% from himself and everyone he worked with. Often, I would see him lose his cool when someone on the crew or in the studio was lagging.

One of the biggest challenges of either directing or producing a music video for Tupac was to keep up with his speed.

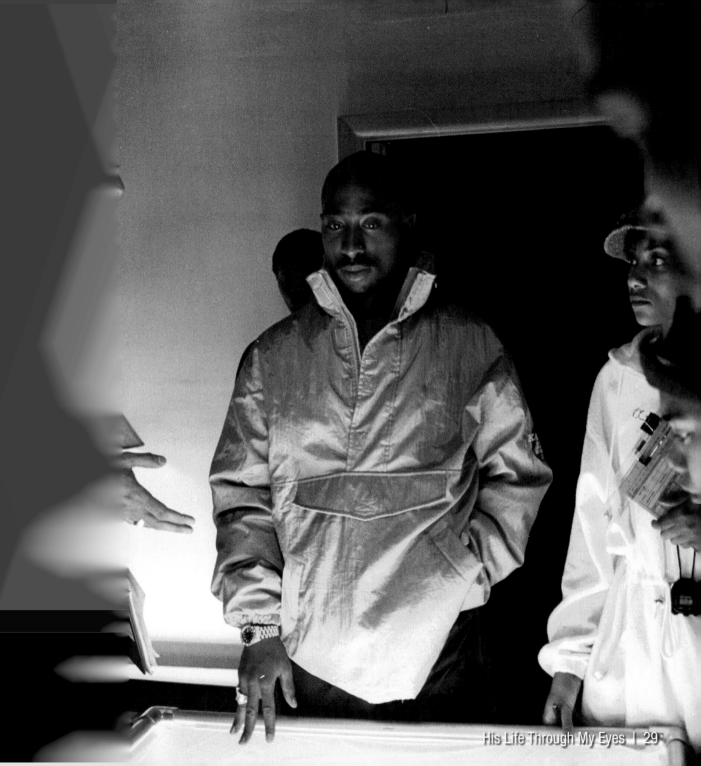

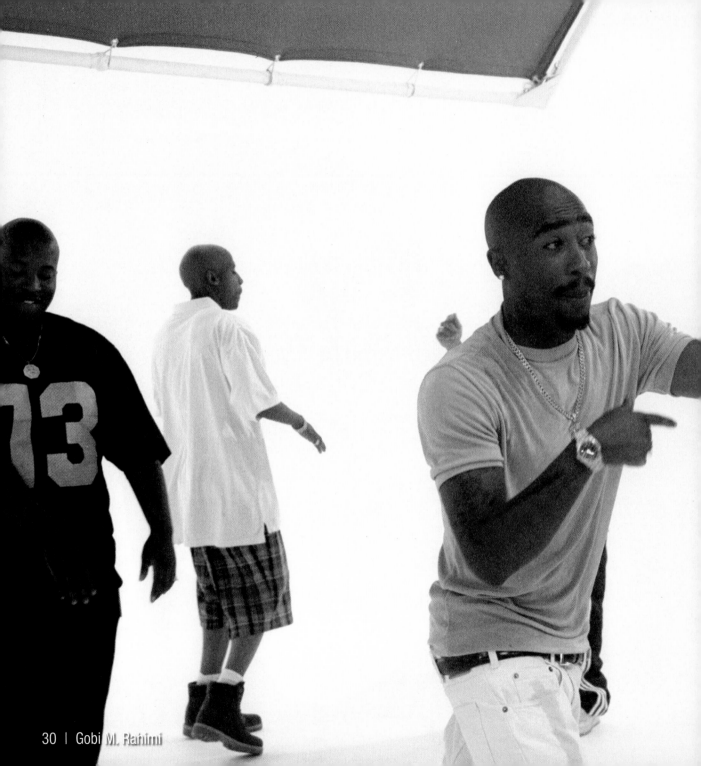

Waiting for the next setup, Tupac was always either busy checking out the next shot or on the phone doing business.

Tupac was always ready to push the envelope. Once he came up with a theme or an idea for the next job, Tracy and I would drop everything and get on it.

He never stopped moving. In between takes, I always wondered what he was thinking. It seemed as though he was pondering his next move in life and how to handle the obstacles that lay before him.

One night, Tracy and I were summoned to Tupac's apartment on Wilshire Blvd. Tupac began to discuss with us his plans to start a production company. A couple of studios were ready to offer him a multi-picture deal. He had decided to make Tracy and I his partners. Tracy and I were absolutely ecstatic. We were going to shake up the film industry.

One important facet of Tupac's personality was his sense of humor. Although he was serious most of the time, he always had time to make fun of himself and others. The above picture who's Pac impersonating Rick James. We shot video footage of him performing his own version of "Super Freak". I had the pleasure of working with Rick James in 1998 and showed him the video footage. Rick practically fell on the floor laughing. After he composed himself, he mocked, "If that nigga was alive, I'd kick his ass."

Whether in a still photograph or on video-tape, being like a fly on the wall afforded me a candid look at Tupac with his guard down. Although he was always surrounded by people, at times he would seem sad and very much alone.

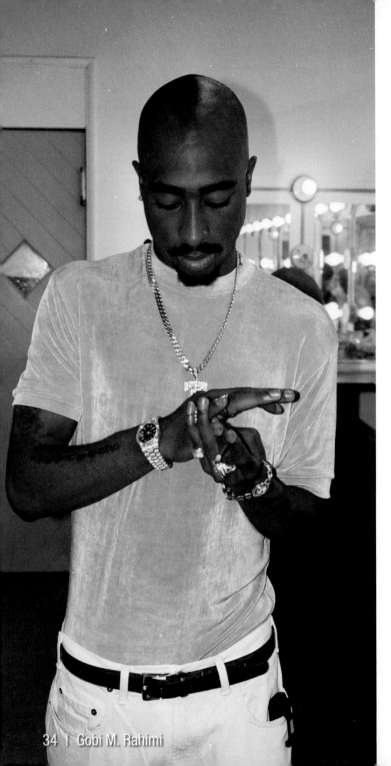

There are many photographs of Tupac where he is looking down or to the side, as if in deep thought. He had his hands full, supporting a large family and dealing with the dark forces that surrounded him. Ironically, when he smiled, I couldn't avoid noticing a profound sense of sadness just underneath his sparkling eyes.

There was a powerful rage that fueled Pac's energetic performances. I've worked with a lot of artists since his passing, but have yet to experience anyone with his type of energy in front of the camera.

Tupac was a true Gemini. Being in his presence on a daily basis allowed me to see many sides of him. He was at once a very serious, uncompromising workaholic who expected everyone to stay up (literally, Tupac could work twenty-two hours a day). Pac was also an accepting, loving, and hilarious. He symbolized innovation and moved at lightning speed. He put every-one to the test. He pushed the Outlawz on the flow and speed of their delivery. He also pushed my crews when I produced or directed music videos for him. He was a conflicted human being who was evolving into a stellar one.

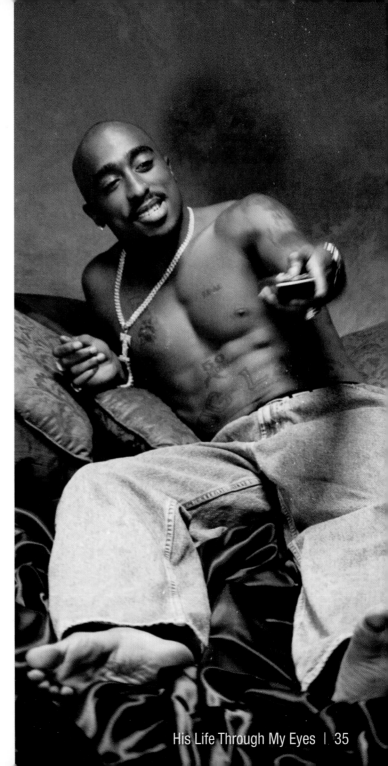

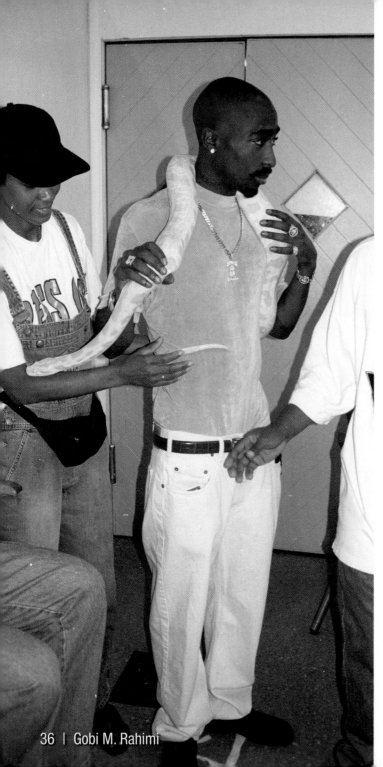

Tupac's name means the "shining serpent". *The Art of War* by Sun Tzu, which was one of Tupac's favorite books, teaches you to keep your friends close and your enemies closer, so that you can be aware of their actions.

Tupac would shoot a movie during the day, a video at night, and if he had any extra time in a twenty-four-hour period, he would make his way to the studio and drop a couple of tracks. If he could, he'd sleep in the limo, between locations. If Tupac was able to sleep in his own bed, his assistant was the one who usually woke him up in the morning. We used to hear all kinds of "Tupac not wanting to be woken up" stories. We learned early on that waking Tupac in the morning was a thankless job.

Tupac was a true perfectionist. He enjoyed things of superior quality. He made sure that every representation of him was of the highest caliber.

The environment Tupac lived and worked in was nothing less than intense. My relationship with Tupac began to take precedence over all of my other relationships. I know I was someone he could depend on. At times I felt as though we were a strong yet vulnerable team, one moment conquering

the world and the next being swept up in a tornado that was looming on the horizon. My time with Tupac was some of the most rewarding, yet scary periods of my life.

When it came to production, Tupac always had a clear vision of what he wanted to achieve.

He knew exactly what he wanted and demanded pure dedication. His favorite name to call the inept was "goatmouth mothafucka".

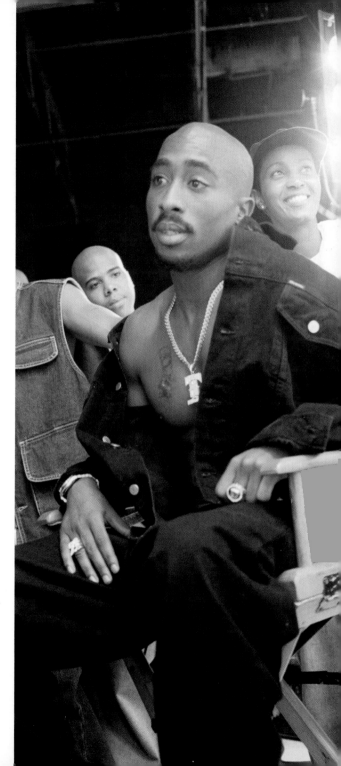

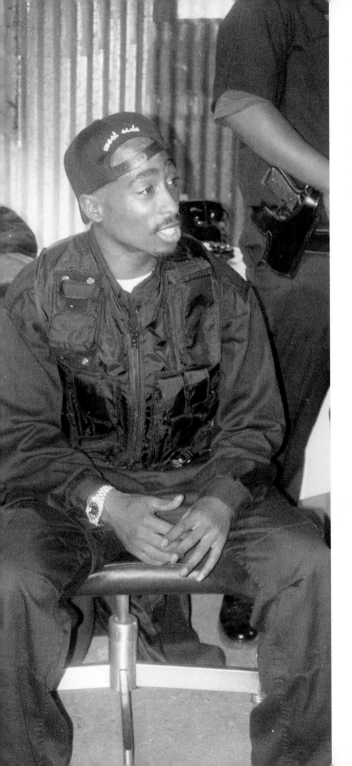

Tupac was notorious for his run-ins with the law. These run-ins motivated the use of police disguises used in the making of the "Made Niggaz" short film. Unfortunately this project never made it to fruition. Luckily, I was able to salvage a music video out of the footage.

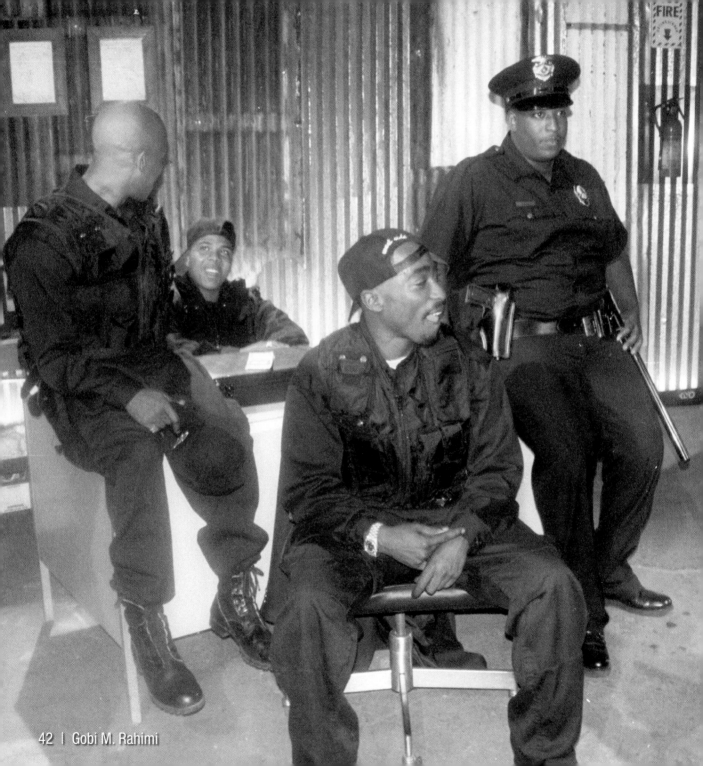

We had a large number of explosions and gunplay in the "Made Niggaz" video, which required a lot of professionals (pyrotechnicians & VFX people) to get the set ready. The excess time it took to get all the firepower ready frustrated all the artists involved.

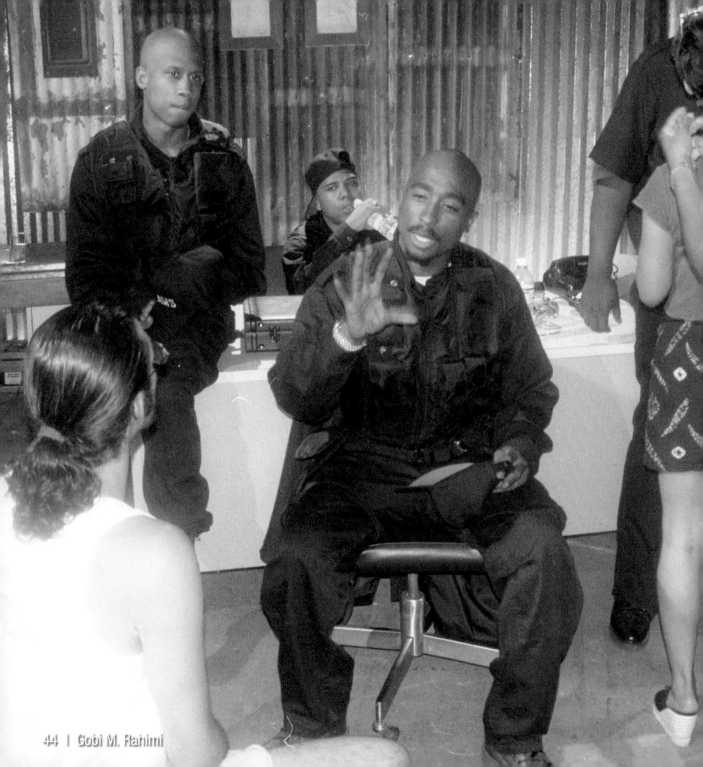

Tupac was a true professional and would deliver 100% of the time. Tupac would move, bounce around, and perform for the camera with a fervor and energy matched by no other.

Tupac would want to shoot a four-day movie in eight hours. Most revolutionaries have a constant pre-occupation with time. They know that tomorrow is not promised.

Even though working with Tupac could be very taxing, the crew seemed humbled in his presence. It seemed like everyone tried their best to give him what he wanted.

A perfect example of Tupac's seldom exposed humorous side. Here he is demonstrating to an Italian chef the proper way to cook pasta!

Yafeu (Yaki) of the Outlawz was extremely close to Tupac. The two of them were like blood brothers. Yaki told people that he had witnessed Tupac's shooting. A few months after Pac's passing, we went to Atlanta to work on a Tupac memorial, for Afeni Shakur. The day after we completed filming the memorial, we received a call from Tupac's fiancèe Kidada Jones alerting us that Yaki had been shot. Molly his assistant, rushed up to New Jersey and was by his side until Yaki's mother Yaasmyn arrived. Yaki passed away that day. To this day, it's still hard to believe that neither Tupac nor Yaki are still alive.

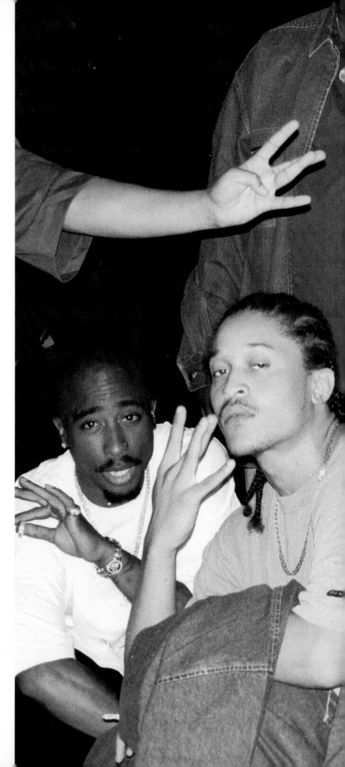

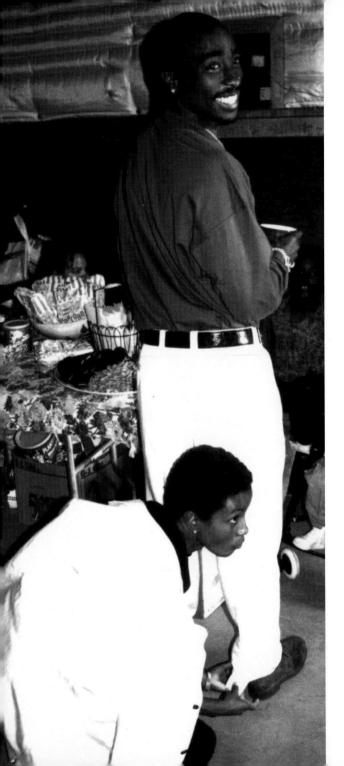

Dye Charles was Tupac's stylist and always had him looking dapper.

As a director, it was always a pleasure to work with Tupac. He was always ready to try something new, different, and challenging. He had exquisite taste. If something made sense and felt good, he tried it. His record company fought him regarding the concept for the "Pour Out a Little Liquor" video. The concept wasn't thug or street enough for them. The label did not like the idea of Tupac being dressed in period-piece clothing. Tupac did not relent; however, the label would only agree to use the footage if Tupac book ended the video with some contemporary thug-type footage. Needless to say, Tupac didn't show up for the extra shoot.

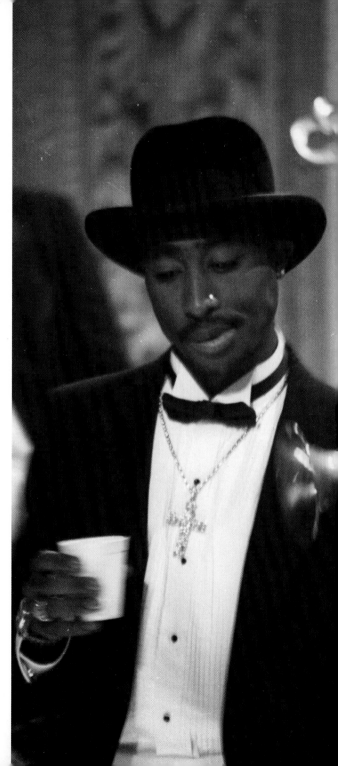

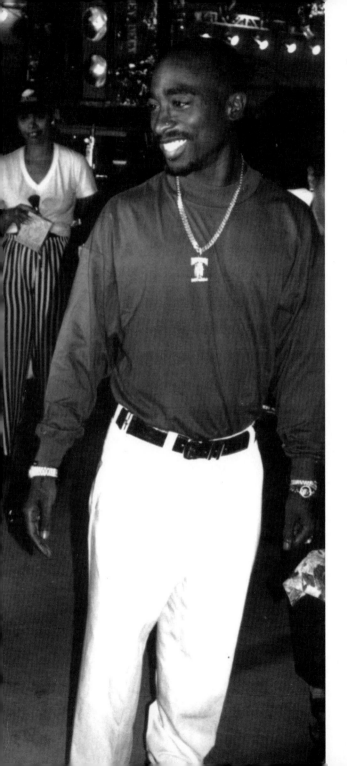

Tupac seemed his happiest when he was on set or in the studio. He was a powerful motivating force to everyone around him.

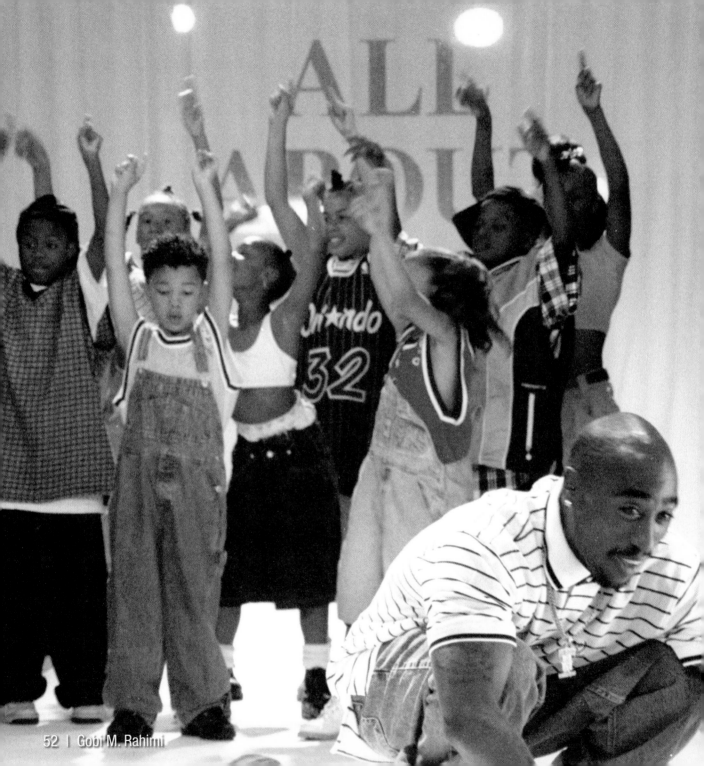

Tupac loved children. I think it was the innocence they possess that drew him towards them. He was always known to be innovative and unconventional. In the "All About You" video he mixed in dancing children, who were chosen from a group of disadvantaged children. After the video shoot, Tupac anonymously paid for one of the girls to go to a dance academy.

Tupac loved his fans. Even here on the busy set of a video, he took time between takes to give some love.

Tracy and I were producing a PG and R-rated version of a video called "How Do U Want It", which had a lot of naked women running around on the set. Not wanting to make the girls uncomfortable, Pac asked all the crew to take their shirts off during the shoot. It was quite a site, and allowed for everyone to drop their guard.

After the video shoot, Pac had a party at his hotel suite with the director of the video and most of the women in the video. That party was everything but a PG night!

Months before his death, I was shooting footage of him for a documentary. One night at his house in Calabasas, he said, "If the powers that be, build a youth center for us in each and every ghetto in America, I'll kiss Biggie on the cheek and perform at each and every one of them for free."

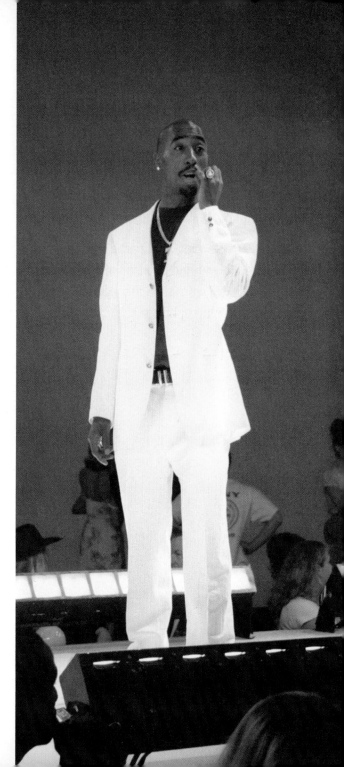

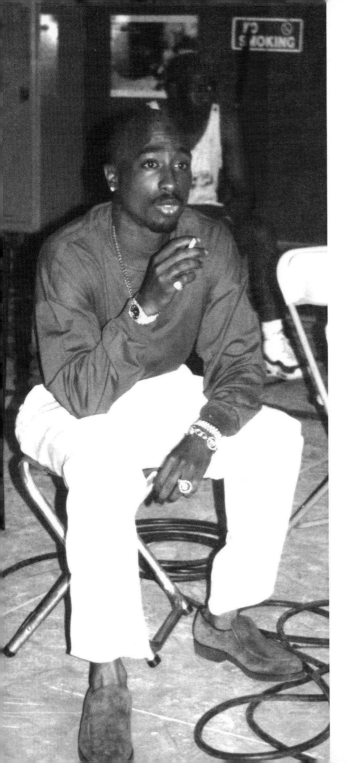

His infamous Hush Puppy shoes; we all had them in a variety of colors.

Tupac treated his music and film crews with respect. I feel that working on music videos and film sets over the years taught him an appreciation for the production process itself.

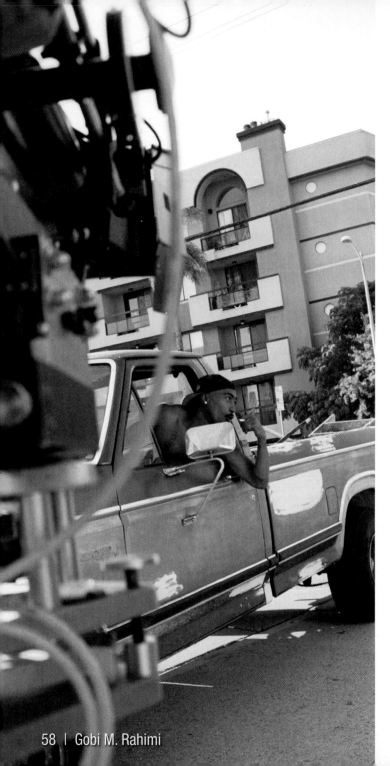

I bought this truck with the intention of tricking it out. Pac used it in a short film we were shooting. A week after he passed away, I was side swiped and the truck was totaled.

Tupac was starting to crave his own autonomy. He was meeting with film studios and said that they were all willing to start working with him. It was on the one condition that he would stay out of legal trouble, which he did.

Despite his sometimes-stressed surroundings, Tupac was still able to kid around and have fun. Here he is giving makeup tips to one of the Outlawz, Hussein Fatal.

Tupac had serious issues with the whole Bad Boy camp. Although I wasn't aware of all the intricacies of the entire situation, I had grown to know Tupac as a very loyal person. He was a man who was forthcoming and without a bullshit veneer. He approached the dissing he did in his videos, with the scorn of betrayal.

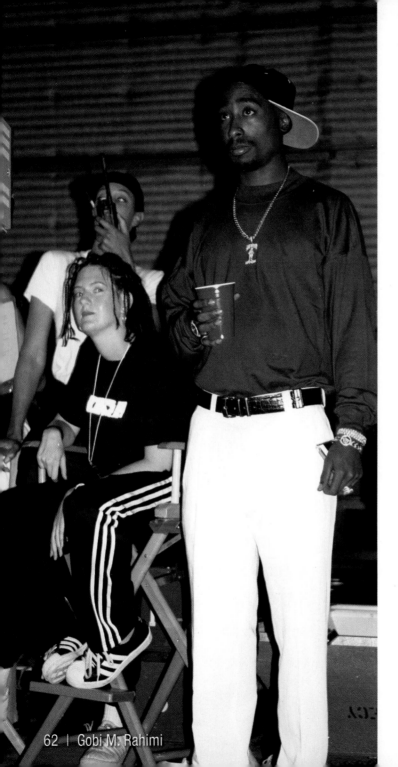

Eager to watch the last setup and analyze his performance, Tupac attentively watched the playback monitor. If he wasn't happy with his performance, he would do it over.

The media fanned a misconception that Tupac was a misogynist. I think it was far from the truth. The Blocker sisters proved to be a perfect example; they were beautiful women who were simply friends.

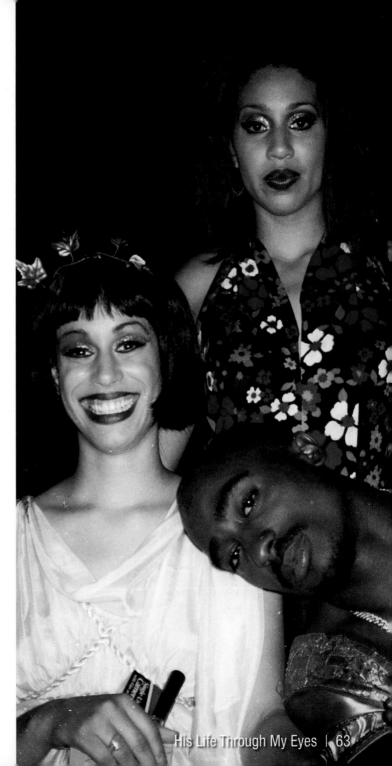

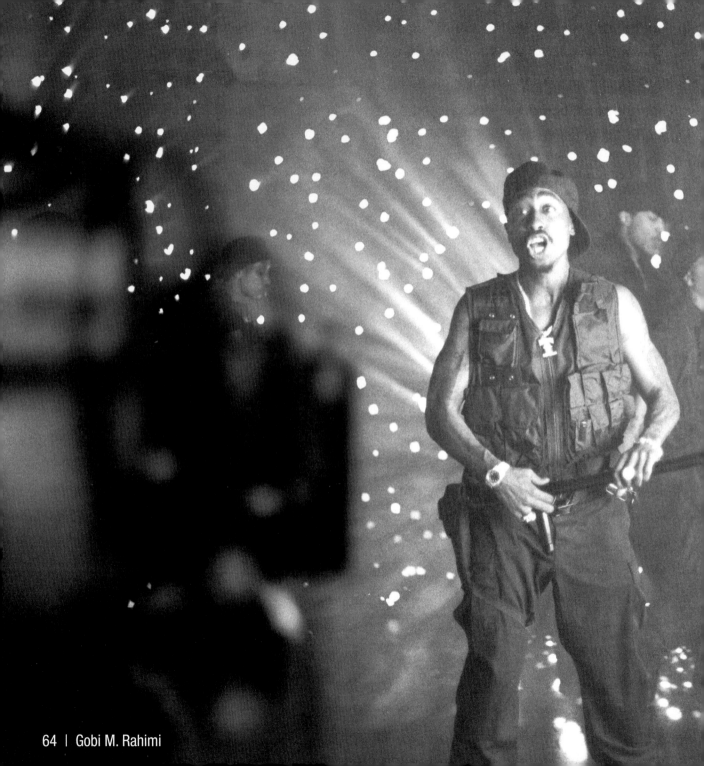

Tupac was on his way to Italy with Kidada Jones to perform in a Versace fashion show. I pleaded with him to let me go so I could shoot stills and video, but he wouldn't let me go. He said he wanted time alone with his lady. I later saw pictures of him on the runway looking very happy.

Tupac liked wearing swat gear. I think the amount of times he was harassed by police was the motivation for the pleasure he received each time he wore any of their uniforms. His band of Outlawz were always ready and willing to do whatever he wanted in the name of performance.

Tracy, Tupac, and music video director Marlene Rhein (director of "All About U") and radio personality Theo, who was the first DJ to announce Pac's passing on September 13, 1996.

In this photo Edi is getting a once over by the hair stylist. Pac would oversee every move involving The Outlawz and would often use humor in doing so.

Tupac trained the Outlawz not only in regards to music and film. He was their life coach. His love for them was genuine, and was apparent in this connection with them.

Here he is clowning around with them.

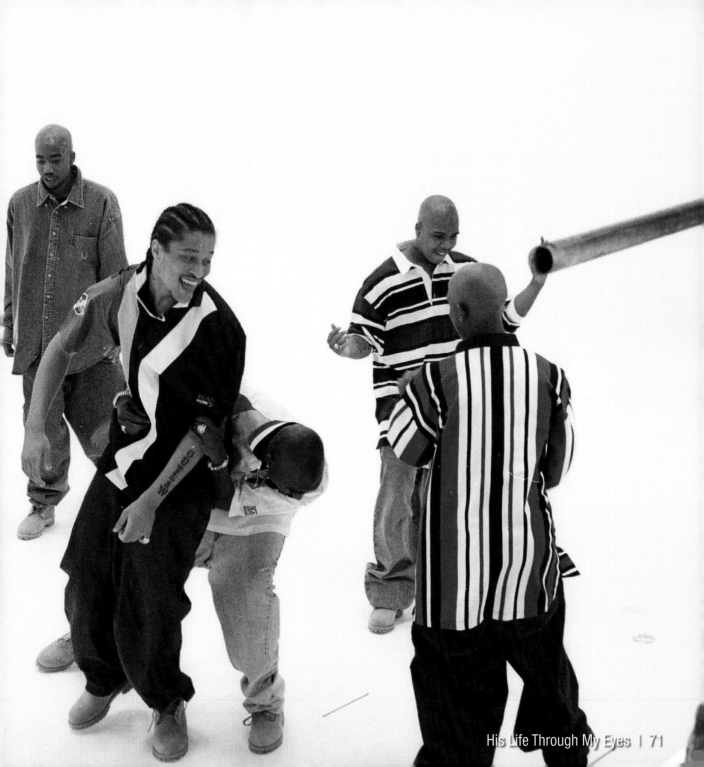

I caught Tupac cooling himself off on the set of the "Hit 'Em Up" video.

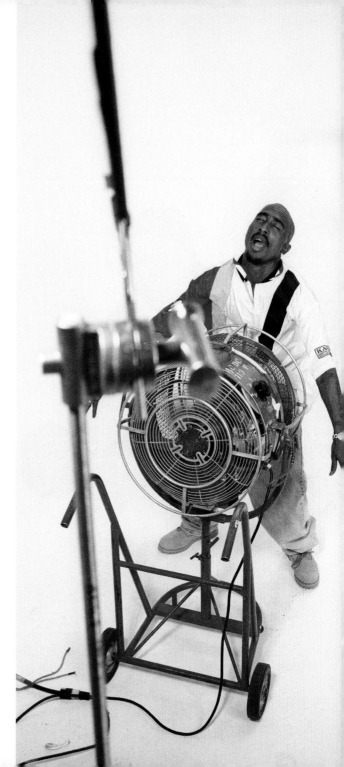

A couple of weeks before the shooting in Las Vegas, Suge Knight had invited Tupac to go to Vegas to no avail. On September 7, Tupac agreed to go to the Tyson fight and headed to Vegas midday. September 7 also happened to be Tracy's birthday, so I suggested we gather our production crew, rent a passenger van, and head to Las Vegas to celebrate Tracy's birthday with Pac. Tracy would have loved to have been around Tupac, but wasn't really into the idea of being around Death Row energy. She finally succumbed to my stubbornness.

We planned to meet Tupac at Suge Knight's Club 662, following the Tyson fight. The fact that the spot was filled with thugs and hustlers didn't excite Tracy in the least bit. We milled around for a while, waiting for Tupac to arrive, when Nate Dogg approached us and said that Tupac and Suge had been shot.

His Struggle
to Survive

Day 1 of his struggle to survive

Tracy and I made our way to University Hospital. Once we got there, we saw Tupac's fiancée Kidada and his cousin Jamala. They were on the phone and both crying. I thought that he must have passed. I came to find out that he was having some corrective operations, but that he was still in critical condition. That night was one of the longest nights of my life. We stayed there through the night and into the next morning.

Day 2 of his struggle to survive

I found myself in a daze, staring through the double doors of the ER waiting for something, anything that would give me hope. I really wanted to go in and see him. Ironically, I felt as though I was back outside of The Clinton Correctional Facility. All I could do was pray to God for him. A nurse walked out and told us that he had gone through a very critical evening and, although his condition was grave, he was stabilizing. By plane and by car, his loved ones made their way to Las Vegas to be by Tupac's side. Yaasmyn, Molly, the Outlawz, and I set up a twenty-four-hour watch. The hospital administrator gave a news conference, updating the media on his condition. We prayed as the evening came and went.

Day 3 of his struggle to survive

A nurse came out in the morning and told us that they had to sedate Tupac and induce a coma-like state because he kept struggling to get out of the bed. The Outlawz, Yaasmyn, Molly, Tracy, and myself were like an army at the side of our wounded leader. Tupac's mother and her sister Glo arrived at the hospital. I had met Afeni once or twice, but had not yet established a relationship with her. Her revolutionary past was all I knew about her. She walked into the hospital accompanied by some

family members. I felt terrible for her. All I could do was think about what my mother would have gone through if I had been in that hospital bed. Kidada's mother Peggy Lipton arrived at the hospital. It was a sad sight to see Kidada and her Mom sitting in their car in the parking lot of the hospital.

Day 4 of his struggle to survive

A number of Tupac's friends came to visit him; YoYo, Snoop Dogg, MC Hammer, Jasmine Guy, Jesse Jackson, Danny Boy, Tupac's brother Mopreme, and many others. Tracy had to go back to LA to prep for a music video. Tupac's biological father arrived at the hospital. He didn't have enough money for a room, so I offered to share my room with him. Tupac's condition was still grave and questionable; despite this, we all remained hopeful. One of his nurses came to the waiting area around 4:00 a.m. and said that she almost lost him, but was able to bring him back after giving him a shot of adrenalin. Standing guard at the hospital was a frightening experience for all of us. There were death threats and all sorts of unsavory characters milling about. We were finally able to get the FOI (Fruit of Islam) to

come and stand security. For the first time, it felt a little safer at the hospital.

Day 5 of his struggle to survive

The waiting room started filling up with Tupac's fans. A female reporter—posed as an upset family member—did her best to get information out of me, but Molly escorted her out. At around 3:00 a.m. the same nurse who had come out the previous night walked up to me and asked me if I wanted to go in and see him. It would be my first time to see him, since the vigil at the hospital began. I was afraid of what I would see. Nothing could have prepared me for what I did see. I had only seen Tupac coherent and full of life. When I walked into the room, I saw his bandaged-up body covered by a thin white sheet. He had tubes and machines protruding from all over. Bandages covered all of his bullet wounds and one of his fingers was missing. His head was swollen as a result of all the medication they had pumped into him. I walked over to him and put my hand on his arm. It was cold. I said a prayer and silently walked out of the room.

Day 6 of his struggle to survive

The sixth day was the same as the previous five. The nurse came out and told us that his condition had improved by 13%. I called Tracy and gave her the news. She asked me to fly back to LA, because she needed help on the video she was working on. I decided to say my goodbyes to the family and leave. That night was a difficult one for Tracy and I. Neither one of us could sleep.

I felt a tremendous amount of guilt for not being by Tupac's side. All I could do was to pray for him.

Day 7 of his struggle to survive

Tracy and I were picked up by our production staff in a van. We were on the 10 Fwy on our way to downtown Los Angeles to a music video shoot. The car was quiet except for the radio. Theo from 92.3 The Beat (a local radio station) announced that Tupac had passed away only a few minutes earlier. Everyone in the van was silent. All I heard was Tracy's feeble cry. I prayed for his soul and was glad that he was out of pain. That was one of the saddest days of my life.

The last time I saw Pac, was at his house in Calabasas. He said, "In six months, people aren't going to recognize me 'cause I'm going to act like such an adult. Who knows, one day I might even run for Mayor of Los Angeles." It's now been twenty years since Tupac has passed and I have come to realize that one of the main lessons I learned from him, is to be fearless and share your truth.

This is why I have finally decided to make a film and tell my story, of how a young Iranian man who started as a Real Estate agent in Orange County, started producing and directing MTV's most watched music videos, and ended up sitting security for the last 7 days of Tupacs life.